1 MONTH OF
FREE
READING

at

www.ForgottenBooks.com

By purchasing this book you are eligible for one month membership to ForgottenBooks.com, giving you unlimited access to our entire collection of over 1,000,000 titles via our web site and mobile apps.

To claim your free month visit:

www.forgottenbooks.com/free893098

ISBN 978-0-265-81147-4
PIBN 10893098

A
CATALOGUE

OF THE WHOLE OF THE

CAPITAL, GENUINE, and SINGULARLY VALUABLE

Collection of Etchings,

BY

REMBRANDT, AND HIS SCHOLARS,

OF THE LATE

DANIEL DAULBY, Esq.

OF LIVERPOOL,

DECEASED.

WHICH WILL BE SOLD BY AUCTION,

By Mr. Christie,

At the Great Rooms of Meffrs. COLNAGHI, SALA, and Co.

PRINT MERCHANTS,

N°. 23, Cockfpur Street, oppofite to Great Suffolk Street,

ON

Wednesday, May 14, 1800, and Three following Days,

AT TWELVE O'CLOCK.

May be Viewed Four Days preceding the Sale, when Catalogues may be
had, at One Shilling each, at Meffrs. COLNAGHI's, and in Pall Mall.

THE truly Capital, amd Valuable Collection of Etchings by Rembrandt, and the celebrated Artists of his School, which is now submitted for Sale, was the Fruit of a long, and assiduous Research, in the course of Thirty Years, by the late DANIEL DAULBY, Esq. of LIVERPOOL, well known to the Connoisseurs in general by the Improved Edition, which he has presented to the Public, of the Works of Rembrandt and his School.

The same correct Judgement which fitted him in so superior a Degree for revising that valuable Work, is also displayed in the choice of Specimens comprised in this Collection, the Whole of which was formed at an unlimited Expence. The Impressions are in general singularly fine, and in perfect Condition; the Variations uncommonly numerous; and the Assemblage of Works by the Disciples, and Imitators of this great Master is so extensive, that it is presumed the present Collection may be justly considered as the most complete existing.

Conditions of Sale as Usual.

First Day's Sale.

WEDNESDAY, MAY the 14th, 1800.

SCHOOL OF REMBRANDT.

Prints after the Pictures and Designs of Rembrandt by other Engravers.

1 SIX Portraits by Worledge, &c. — — — — —
2 Ten ditto by Capt. Baillie, &c. — — — —
3 Six ditto, Mezzotintos, by Vaillant — — — —
4 Eight ditto by De Marcenay, &c. — — — —
5 Seven ditto by Prenner, &c.—2 *of them proofs* — —
6 Six ditto by Picart, &c. — — — — —
7 Ten ditto by Ciartes — — — — — —
8 Two Mezzotintos by Houston—*very fine* — — —
9 Four ditto, various;—2 *of them proofs* — — —
10 Four, John Lutma, the Goldsmith by Filloeul, man in a broad Hat by Dupius, Junior, another by Danzell; and another by Houbraken—*proof*
11 Four J. Lutma by his son—*fine.* Two by Filloeul, and portrait of Swalmius, by Suyderhoef — —
12 One. The Burgomaster, Six, by Bafan—*very fine* on India Paper — — — —
13 One ditto, Mezzotinto—*fine proof* —
14 Two, a piping girl by M'Ardell, *fine proof*; and portrait of a man by Pether, *ditto* — — —

15 Two portraits, Mezzotintos, by Pether

16 One, the Jew Rabbi, by Pether, 1778

17 One ditto, ditto, 1764, *very fine*

18 Two portraits, Mezzotintos, by Haid—*proofs*

19 Two, Prince Rupert, by Val. Green—*fine proofs,* and Van Tromp by Graham, ditto

20 Two. A lady reading, by Earlom, and the School Miſtreſs by Walker

21 Two. Eruditi anonymous Don du Bious, fecit; and Philoſopher in Contemplation by Phillips—*fine proof*

22 The Burgo-maſters, from the picture in the Stadt-Houſe, at Amſterdam, by Houſton

23 Ten various, Hiſtorical

24 Six ditto,—1 *a fine proof*

25 Eight ditto,—2 *of them proofs*

26 Four ditto St. Anaſtaſius by Balliu.—*very fine, &c.*

27 Two, the gold weigher by Vander Bruggin; and a Man mending a pen by Houſton,—*fine proof*

PORTRAITS OF REMBRANDT

BY VARIOUS MASTERS.

28 Three, portrait of Rembrandt, by Heſs. Another ditto by Worlidge—*fine proof.* Another ditto by Martin, 1765, Mezzotinto

29 Two, one ditto by Townley. Another ditto by Gole —*fine proof*.

30 Three. One ditto by Townley, different from the laſt. Another ditto by Seuter ; and another ditto by Van Bleek.

31 Two, by Earlom, proof and letters—*very fine*

32 Four. One by Worledge: One ditto, marked R
M. One ditto, Rembrandt and wife, marked
B. G, *comme Mari et Femme*; and One, Rem-
—brandt's friend, by Romani ————————

33 One. Rembrandt's Frame Maker, by Dixon,—*fine*

34 Two. One, Rembrandt's Miſtreſs, by Haid; and
one, Rembrandt's Mother, by Ditto ————

35 Two. One, Rembrandt's Wife, by Earlom; and
one Ditto, different, by Houſton—*proof*————

36 Two. One Rembrandt's Mother, by Lauw; and
one Ditto by M'Ardell—*very fine proof* ————

ETCHINGS BY REMBRANDT.

*Portraits of Rembrandt, or Heads which reſemble
him.*

*N. B. The Number annexed to each Print, refers to the
Catalogue of Rembrandt, publiſhed by Mr. Daulby.*

37 Three. Portrait of Rembrandt, by Gole—*fine proof*
(No. 1). Buſt of a Young Man, reſembling
Rembrandt, (No. 2); and a Head much reſem-
bling Ditto—*very ſcarce*, (No. 3).

38 The Bird of Prey, Portrait—*extremely rare*, (No. 4).

39 Buſt of a Young Man, reſembling Rembrandt—*very
fine and rare*—(No. 5).

40 A ſmall Head ſtooping—*fine and rare*—(No. 6);
and Buſt of a Young Man—*Ditto*—(No. 7)———

41 Portrait of Rembrandt when Young—*extra fine and
rare*, (No. 8)

42 Head reſembling Rembrandt—iſt Impreſſion—
very rare, (No. 9); Ditto—3d ditto, (No. 9)

and a Buft in which is fome refemblance of
Ditto—2d. Impreffion, (No. 14)

3 - 16 44 Ditto, *before the Plate was cut,*—*1ft Impreffion*—*extra
fine and rare,* (No. 14) T—TA

3 - 19 45 Portrait of Rembrandt when Young, half length,
—*on India Paper*—*very fine and extremely rare,*
(No. 15).

4 - 13 46 Buft of Titus, Son of Rembrandt,—*very fine, and
a great rarity,* (No. 16)

1 - 7 47 A Young Man, Mouth open—*very fcarce,* (No. 18);
a Buft which refembles Rembrandt—*ditto,* (No.
19)

48 Buft refembling Rembrandt,—*1ft Impreffion*—*fcarce.*
Ditto—*finifhed Plate,* (No. 20), and Rembrandt
in a Cap like a Turban, (No. 21)

49 Rembrandt with an Epaulette, (No. 22), and
Ditto with a Drawn Sabre—*fcarce*—(No. 23)

5 - 6 : 50 Rembrandt and his Wife—*beautiful,* (No. 24)

10 - 6 51 Rembrandt in a Mezetin Cap and Feather—*ditto,*
(No. 25)

1 - 4 52 A fine Portrait of Rembrandt, a half-length—*ditto,*
(No. 26)

1 - 4 53 A Portrait of Rembrandt, Drawing —*fine,* (No. 27)
and a Ditto—*ditto,* (No. 28)

19 54 A Portrait of Rembrandt, drawing, *before the Land-
fcape*—*extremely fine and rare,* (No. 27)

SCRIPTURE SUBJECTS FROM THE OLD
TESTAMENT.

11 - 6 55 Adam and Eve,—*very fine* (No. 29)

56 Abraham entertaining the Three Angels, (No. 30)
19 - 6 Abraham fending away Agar and Ifhmael,—
very fine (No. 31)

Vernon 57 Two, Abraham and his fon Ifaac, (No. 32). and copy reverfed.

Claufon 58 Two, Abraham's Sacrifice,—*very fine, with the Bur.* (No. 33) and copy reverfed

N. Smith 59 Five, Jacob's Ladder 2d and 4th imp. (No. 34). and the Image which Nebuchadnezzar faw in his Dream, 2d and 3d imp. (No. 34). and the Vifion of Ezekiel, 2d imp. (No. 34)

Manson 60 *Four Cuts for a Spanifh Book, complete, all of them firft impreffions ;—extra fine and rare,* (No. 34)

Claufon 61 Three. Jacob lamenting Jofeph, (No. 35) *Original and Copy, and reverfe of Original*

N. Smith 62 Jofeph and Potiphar's Wife,—*very fine* (No. 36)

Manson 63 Two. Jofeph telling his Dream, *wafhed with Indian Ink ; and reverfe,* (No. 37)

Gillow 64 Two. Ditto, 1ft and 2d impr. (No. 37)—*beautiful*

N. Smith 65 Two. Gideon's Sacrifice (No. 38) and David on his knees, (No. 40)

Ja 66 Haman and Mordecai, 1ft Imp. (No. 39)—*with the Bur, very fine and rare*

Vernon 67 Two. Tobit, (No. 41); and the Angel afcending from Tobit and his Family,—*extremely fine,* (No. 42)

N. Smith 68 The Angel appearing to the Shepherds—*moft beautiful Impreffion*—(No. 43)

Manson 69 Two. The Nativity, or Adoration of the Shepherds, (No. 44) ; and the Circumcifion, (No. 46)

N. Smith 70 Two. The Nativity, a Night Piece—2d *and beft Impreffion, and* 3d *Imp.* (No. 48)

Ja 71 Two. The little Circumcifion, —*very fine* (No. 47); and a Circumcifion, (No. 48)

France 72 The Prefentation of Jefus in the Vaulted Temple, (No. 49)— 2d *Imp.*

73 Ditto, (No. 49)—FIRST IMP.—*before the Cap on the Head of the High Priest.—extremely rare* X G. *Manson*

74 The Presentation, in Rembrandt's Dark Manner, (No. 50)—*1st Impression—very fine and rare* TC N. *Smith*

75 Three. The Presentation, with the Angel, (No. 51)—*most beautiful Impression;* and the Flight into Egypt, (No. 52) and Copy

76 Two. Flight into Egypt, a Night Piece, (No. 53) —*4th and 5th Imp.*

77 Two ditto, *reverse of 1st Imp. and 2d ditto*—(No. 53)

78 Three. The Return from Egypt—*very scarce, with the Bur,* (No. 54). The Flight into Egypt, Holy Family crossing a Rill—*1st Imp;* and another Ditto, singular, (No. 55)

79 Flight into Egypt in the Style of Elsheimer, (No. 56)—*3d Imp.*

80 Ditto, (No. 56)—*2d Imp.*

81 Ditto, (No. 56)—*on India Paper*—THE FIRST IMPRESSION—*extremely rare* X G.

82 Two. The Rest in Egypt—*1st and 2d Imp. beautiful*

83 *Three Pieces, lightly etched,* (No. 58)—*very scarce, viz.* The Rest in Egypt. St. Peter; and a Man with a Pen X C

84 Three. The Virgin and the Infant Jesus in the Clouds, (No. 60). The Holy Family, (No. 61); and Ditto looking in at the Window, (No. 62)

85 Three. Jesus disputing with the Doctors in the Temple, (No. 63). Ditto on the same Subject, (No. 64), and Ditto, (No. 65)—*scarce*

86 Two. The Tribute of Cæsar—*1st and 2d Imp. very fine,* (No. 67)

87 Christ driving the Money Changers out of the Temple, (No. 69)—FIRST IMPRESSION—*very scarce*

88 Two. The Prodigal Son, (No. 70)—*1ſt Imp.* and C—Jeſus and the Samaritan Woman, (No. 71)

89 Jeſus and the Samaritan Woman, upright, (No. 72) —MOST BEAUTIFUL IMPRESSION

90 Two. The ſmall Reſurrection of Lazarus, (No. 73), and the larger Ditto, (No. 74)—*very fine*

91 The Hundred Guilder Piece—A REMARKABLE FINE IMPRESSION, on India Paper, (No. 75) *with a Fragment of the Plate cut*

92 Jeſus healing the Sick—FIRST IMPRESSION, *on India Paper,* (No. 76)

93 The good Samaritan—*3d Imp.* (No. 77)

94 Ditto—2d Imp. (No. 77)—EXTREMELY FINE AND RARE

95 The good Samaritan, (No. 77)—FIRST IMPRESSION, WITH THE WHITE TAIL, BEAUTIFUL AND VERY RARE

96 Our Lord in the Garden of Olives, (No. 78)— FIRST IMPRESSION, UNCOMMONLY BEAUTIFUL

B

Second Day's Sale.

THURSDAY, MAY the 15th, 1800.

Prints after the Pictures and Designs of Rembrandt, by other Engravers, continued.

97 TWO. The Mathematician, by M'Ardell, and the Nativity, by Ditto—*very fine Proof* *Money*

98 Four, various—1 *a Proof* *Vernon*

99 Four. The Lord of the Vineyard, by Feffard; and the fame fubject, by Martinus, called *Le Negotiant D'Amfterdam.* Jofeph and Potiphar's Wife, by Exfhaw—*fine Proof*, and a Storm, by Ditto *N. Smith*

100 Two. The Angel departing from Tobit, by Houbraken, and the fame Subject, by Walker *Vernon*

101 Three. The Lord of the Vineyard, by Ravenet. Ditto, by Pether—*fine Proof.* Philemon and Baucis, by Watfon—*Ditto* *N. Smith*

102 Three. Nativity, by Bernard, 1ft and 2d Imp. and Age, by Greenwood *Vernon*

103 Sufannah and the Elders, by Earlom—*fine Proof*

104 Abraham's Sacrifice, by Haid—*fine* *Mancon*

105 Another, Ditto, by Murphy—*ditto*

106 Two. The Prefentation in the Temple, by Earlom, and Elijah raifing the Widow's Son, Ditto *Colnaghi*

Vernon 107 Two. Our Lord and the Woman of Samaria, by Houfton—*Proof*, and Haman's Condemnation, by Houfton ✗

108 Two. Judah and Tamar, by Dunkarton—*fine Proof*, and the Tribute Money, by M'Ardell—*Ditto*

109 Two. Pyramus and Thifbe, by Canot, and a Family Piece, by Boydell—*fine Proof*

110 Two. Triumph of Mordecai, by Earlom, and Belfhazzar's Feaft, by Hudfon ✗

Colnaghi 111 Sampfon betrayed by Dalila, mezzotinto, by Jacobi

112 Two. A Landfcape, by Chatelain—*fine*, and a Ditto, by Wood—*ditto*

113 Two, by De Marcenay—*Proof and Letters, very fine*

114 David and Bathfheba, by Moreau—*Ditto*

Leighton 115 Two. Tobias recovering his Sight, by De Marcenay, and Portrait of a Lady and Gentleman, Ditto

116 Four Heads, by Schmidt

117 Seven Ditto, by Ditto ✗

118 Three, Hiftorical, by Ditto—*fine*

119 Four, Ditto, by Ditto

120 Six, from the Duffeldorf Gallery, by Heffe

Vernon 121 Three. Chrift difputing with the Doctors, and —2 Portraits, by Heffe

122 Two, by Captain Baillie

Vernon 123 A Portfolio containing 78 Imitations of Rembrandt's Drawings, by Count Caylus, Pond, Picart, Laurentz, Bertoch, Baillie, and others, Half Bound, Morocco Back;—lettered " Rembrandt's Works"

ETCHINGS BY REMBRANDT CONTINUED.

124 Our Lord before Pilate—3d Imp. (No. 79)

125 Ditto, 2d Imp. (No. 79)

126 Ditto, WITH THE BUR, FIRST IMPRESSION, *extremely scarce*

127 Two. The Three Crosses—3d Imp. and a reverse, (No. 80)

128 Ditto—2d Imp. *very fine*, (No. 80)

129 Ditto, (No. 80)—FIRST IMPRESSION, *before the Name and Date, very rare*

130 Two. Our Lord on the Cross, (No. 81)—an **Oval**, and the little Crucifixion, (No. 82)

131 The Ecce Homo, (No. 83)—2d Imp. *very fine*

132 Ditto, (No. 83)—THE FIRST IMPRESSION, *from Capt. Baillie's Collection, very fine*

133 Two. The Descent from the Cross, (No. 84)—2d Imp. and the same Subject, a Sketch, (No. 85)

134 The Descent from the Cross, (No. 84)—FIRST IMPRESSION, *before any Address, extremely rare*

135 The same Subject, a Night Piece, (No. 86) *1st Imp.* VERY FINE

136 Four. Jesus entombed, (No. 87)—*1st, 2d, 3d, and 4th Imp.* VERY FINE AND RARE

137 Three. The Funeral of Jesus, (No. 88). Our Lord and the Disciples at Emaus, (No. 90), and the same Subject, small, (No. 91)

138 The Decollation of St. John the Baptist, (No. 92) —FIRST AND MOST BEAUTIFUL IMPRESSION, *very rare*

139 Peter and John at the beautiful Gate of the Temple, (No. 94)—*2d Imp. very fine, on India Paper*

140 Two. The Baptism of the Eunuch, (No. 95)—*1st Imp. fine*, and the Martyrdom of St. Stephen, (No. 98)—*Ditto*

141 The Death of the Virgin, (No. 97)—*2d Imp.*

142 Three. St. Jerome at the Foot of a Tree, (No. 100)—*1st Imp. extremely fine.* Ditto, Kneeling, arched, (No. 101)—1st Imp.—*Ditto*, and Ditto Kneeling, (No. 103)—1st Imp. *Ditto*

143 Ditto sitting before the Trunk of a Tree, (No. 102)—BEAUTIFUL IMPRESSION

144 St. Jerome, *unfinished*, (No. 104)—*1st Imp.* WITH THE BUR, *very fine*

145 Two. St. Jerome, in Rembrandt's dark Manner, (No. 106), and St. Francis praying, (No. 107) —*scarce*

146 Youth surprised by Death, (No. 109)—very scarce

147 Two. A Man Meditating, (No. 110)—*1st and 2d Imp. very fine*

PIECES OF FANCY.

148 An Allegorical Piece, (No. 111)—EXTREMELY RARE AND FINE

149 The Star of the Kings, (No. 112)—*very fine*

150 Four Hunting Pieces, (No. 113)—*very fine* an rare

151 Two. Three Oriental Figures, (No. 114)—*fine*, and the Blind Bagpiper, (No. 115)—*1st Imp. Ditto*

152 Two. The Rat Killer and Copy, (No. 117)

153 The Goldſmith, (No. 119)—1ſt Imp. very fine

154 The Pancake Woman, (No. 120)—Ditto, ditto

155 Two. The Sport of Kolef, (No. 121), and a
Jew's Synagogue, (No. 122)

156 Fortune, an Allegorical Piece, (No. 123)—1ſt,
Imp. rare

157 The Marriage of Jaſon and Crëuſa, (No. 124)—
3d Imp. fine

158 The ſame, (No. 124)—FIRST IMPRESSION, very
fine, and extremely rare

159 The Corn Cutter, (No. 125)—FIRST IMP. ex-
tremely ſcarce and fine

160 Four. The Schoolmaſter, (No. 126). The
Mountebank, (No. 127). The Draughtſman,
(No. 128), and Peaſants Travelling, (No. 129)

161 Cupid Repoſing, (No. 130)—FIRST IMP. very
rare, and Copy

162 Two. Jew with the High Cap, (No. 131), and
Old Man with a Boy, (No. 132)

163 The Onion Woman, (No. 133)—2d Imp. ex-
tremely ſcarce

164 The Onion Woman, (No. 133)—FIRST IMP.
ALMOST UNIQUE, before the Name of Rem-
brandt

165 Two. A Peaſant with his Hands behind him,
(No. 134)—1ſt Imp. ſcarce, and a Man play-
ing at Cards, (No. 135)—Ditto

166 A Man with a ſhort Beard and a Stick, (No. 136)
—FIRST IMP. very fine and rare

167 Three. The Blind Fidler, (No. 137)—1ſt Imp.
very ſcarce, 2d Ditto and 3d Ditto

168 Two. The Man on Horſeback, (No. 138), and
the Polander, (No. 139)

169 Two. Another Polander, (No. 140)—*1ſt Imp.* _ *12* _
very ſcarce, and Ditto—*2d Imp.*

170 Two. A Man ſeen from behind, (No. 141)—
1ſt Imp. extremely ſcarce, and Ditto—*2d Imp.* — *—1/3* —

171 Four. The Two Travelling Peaſants, (No. 142).
The Old Man without a Beard, (No. 143)— *1 - 4* _
2d Imp. very ſcarce. Ditto 3*d* and 4*th*

172 Two. Old Man with a Buſhy Beard, (No. 144),
and the Perſian, (No. 145)· — *10 - 6*

173 The Aſtrologer, (No. 147) by F. Bol — *11* —

174 The Skater, (No. 151)—PRESQUE UNIQUE *3 - 3*

175 The Hog, (No. 152) *extremely ſcarce and fine* — *10 - 6*

176 The little Dog ſleeping, (No. 153)—*2d Imp.* rare — *8*

177 The ſame, (No. 153). FIRST IMPRESSION, *before
the Plate was reduced,* RARISS *1 - 5*

178 The Shell, (No. 154) *very fine and extremely rare* — *5*

BEGGARS.

179 Two. A Beggar ſtanding—*ſpiritedly etched,* No. *2 - 0 - 3*
155), and a Beggar Profile in a Cap. (No. 156)

180 Three. A Man and Woman Converſing, (No.
157). Two Beggars coming from behind a *1 - 8* —
Bank, (No. 158)—*2d Imp. ſcarce,* and 3*d, ditto*

181 Two Beggars coming from behind a Bank, (No.
158)—FIRST IMPRESSION, *before the Plate was* *1 - 6*
reduced, EXTREMELY RARE

182 A Beggar in the Manner of Callot, (No. 159)— *1 - 3*
very ſcarce

183 Two. A Beggar in a flaſhed Cloak, (No. 160)
1ſt Imp. very ſcarce, and Ditto—*2d Imp. ſcarce*

184 Three. A Beggar Woman, in Callot's Manner,
(No. 161). A Ditto aſking Alms, (No. 164),
and Copy

185 Lazarus Klap, the Dumb Beggar, (No. 165)
—A GREAT CURIOSITY, *very fine, and ex-*
tremely rare

186 The ragged Mariner with his Hands behind him,
(No. 166), and Copy

187 Three. A Beggar warming his Hands over a
Chafing Dish, (No. 167)—*1st Imp. scarce.* A
Beggar with his Mouth open, (No 168)—*1st*
Imp. and Copy

188 An Old Beggar with a Dog, (No. 169)—*extremely*
rare and fine

189 Beggars at the Door of a House, (No. 170) *very*
fine

190 Two. A Beggar, and its companion, (No. 171)

191 Two. A Beggar with a wooden Leg, (No. 172),
and a Peasant standing with his Hands behind
him, (No. 173)—extremely scarce

192 A sick Beggar lying upon the Ground, (No. 177)
—*very fine,* PRESQUE UNIQUE

Third Day's Sale,

FRIDAY, MAY the 16th, 1800.

*Prints after the Pictures of Designs of Rembrandt,
by other Engravers, continued.*

193 FOUR. Portrait of an Officer, by Leeuw.
Ditto of a Lady, by Ditto. Saul and David,
by Ditto; and Tobias, by Ditto

194 Thirty-nine Heads after Rembrandt, or in his
Manner—*very fine*

195 Four. The Virgin's Head, (No. 56). *with the
Bur—very rare.* Two Heads, part of a Plate
of Sketches (No. 330)—*extremely rare*; and
Three Heads in one Plate—*very small unde-
cribed* T △ —⌐

196 The Moor with a Hammer (No. 8, in Supple-
ment) —*from Mr. Barnard's Collection* — EX-
TREMELY RARE

197 A grotesque Head, *from the Cabinet of the Burgo-
master Six*—UNIQUE

198 Two. Old Man's Head, from the Collection of
M. Foulkes, Esq. and David on his knees,
from Pond's Collection

199 Four. Uncertain, Various, 1 by Houbraken
—*fine and curious*

C

200 Two. The Little Tomb, (No. 66)—*fine*; and Family in a Room, by F. Bol

201 Five. A Philofopher, by F. Bol. The Woman with a Pear, by Ditto, a Man writing, by Van Vliet; and two Old Men's Head's, by Koninck

202 Two. Adoration of the Shepherds, by Livens; and an Old Man's Head, by Ditto

203 Two. Johannes Secundus, by Rodermont—*fine*; and a Young Man's Head, by G. V. D. Eckhout, 1646

204 Four. Judah and Tamar, by Laftman—*beautiful Impreffion*—and 3 others

205 Four. A Buft of Rembrandt, Young, (No. 1). Supplement. An Alchymift in his Laboraty (No. 8), Ditto. An Old Man with an Aquiline Nofe (No. 25), Ditto, and a Portrait, of Klaas Van Rhyn (No. 53) Ditto—*all rare*

206 Jacob and Efau, (No. 342), by Verbecq

207 Three. The Return of the Prodigal Son, (No. 343). by Verbecq. A Shepherd fitting under a Tree, (No. 344). by Ditto; and Boaz and Ruth, (No. 346)

208 Two. The Nativity, (No. 347), *extremely rare*; and the Reft in Egypt, (No. 348), *Ditto*

209 The Infide of a Proteftant Church, (No. 353)—FIRST IMPRESSION, *before the Stays that fupport the founding Board of the Pulpit*—EXTREMELY RARE AND FINE

210 Four. The Pen Cutter, (No. 361). A Young Man, (No. 362). An Old Man reading, (No. 365); and an Old Man with a Frizzle Beard (No. 366), by F. Bol

13-12

WORKS OF REMBRANDT's SCHOLARS.

LEONARD BRAMER.

211 A Lady at her Toilet; HIS ONLY ETCHING—*very rare* 9A

Vernon 1 - 5

FERDINAND BOL.

Smith 212 Six Heads, in manner of *Rembrant.* Woman with a Pear, &c.—*very fine* — 18 —

Norton 213 Two. Abraham offering up Isaac; and St. Jerome in the Cavern — 17 —

JOHN LIVENS

Po 214 Two. The Resurrection of Lazarus; and one after Ditto by Louys 1 - 6

Chance 215 Two Heads by Ditto; one in Wood, Curious 0 -

ETCHINGS BY REMBRANDT.

* FREE SUBJECTS EXTREMELY RARE AND FINE

Joullain 216 Ledikant; or the French Bed, (No. 178) Pp 3 - 0 0

Morrison 217 The Friar in the Straw, (No. 179). TX —

218 The Flute Player, 3*d.* *Imp.* (No. 180)—*with a*

Vernon Copy — 5

Budge 219 The fame, 2*d.* *Imp.*—(No. 180) —

Clark 220 The fame FIRST IMPRESSION, (No. 180) TJ 1 - 5

Joullain 221 The Shepherds in a Wood, (No. 181) —

Smith 222 A Man making Water, (No. 182) Ptc —

Lambert 223 A Woman crouching under a Tree, (No. 183) —

ACADEMICAL SUBJECTS.

224 A Painter drawing after a Model, (No. 184)—
unfinished

225 The Prodigal Son, (No. 185); WITH THE BUR—
extremely fine and rare

226 The Go-Cart, (No. 186)

227 Two. The Bathers, (Nos. 187); and a Man fit-
ting on the Ground, (No. 188)

228 A Woman fittting before a Dutch Stove (No.
189), 3d. Imp.—*fcarce*

229 The fame, (No. 189), with a reverfe, 2d. Imp.
—*very fcarce*

230 The fame (No. 189), FIRST IMPRESSION—*very
fine and rare*

231 Three. A Naked Woman, 1ft. and 2d. Imp. and
a Copy by Hollar

232 A Woman dreffing after Bathing, (No. 191)
WITH THE BUR, *on India Paper*—*extremely rare
and fine*

233 A Woman with her Feet in the Water, (No 192)
very fcarce—WITH THE BUR

234 A Woman Bathing near the Foot of a Tree,
(No. 193)

235 The Woman with the Arrow, (No. 194)—*with
the Bur—very rare*

236 A Woman Sleeping, and a Satyr, (No. 195)—
FIRST IMPRESSION—*very fcarce*

237 The fame Subject, fmaller, (No. 196)

238 A Woman naked, feen from behind, (No. 197)
—*very fine*

LANDSCAPES.

256 A large Landſcape, with a Cottage and Dutch Barn (No. 217) with the Copy

257 An arched Landſcape, with the Obeliſk, (No. 218)

258 A Village, with a Canal, (No. 219)

259 An Orchard, with a Barn, (No. 221)—BEAU-FUL IMPRESSION—*extremely rare*

260 A large Landſcape, (No. 222)

261 A Grotto, with a Brook, (No. 223)—*very ſcarce*

262 A Cottage, with white Pales, (No. 224)—*2d Imp. ſcarce*

263 The ſame, (No. 224) FIRST IMPRESSION—*very rare*

264 Rembrandt's Father's Mill, (No. 225)—*ſcarce*

265 The Gold-weigher's Field, (No. 226)—*very ſcarce*

266 Two Landſcapes of the ſame ſize, (No. 227)

267 A Landſcape, with a Cow drinking, (No. 228)

268 A Landſcape, ſurrounded with White Pales, (No. 234)—*on India Paper*—PRESQUE UNIQUE

269 A Landſcape, *from the Earl of Bute's Collection*—UNIQUE, AND EXTREMELY FINE

270 A Landſcape, not deſcribed, *from Pond's Collection*—EXTREMELY RARE

271 A Cottage, *from the Earl of Bute's Collection*, WITH THE BUR.—*extremely ſcarce and fine*

272 Cottages, *from Ditto*—UNIQUE

PORTRAITS OF MEN.

273 A Man in an Arbour, (No. 237)

274 A young Man ſitting in a Chair, (No. 238)—EXTREMELY RARE

275 Three. An old Man with a large Beard, (No. 239)—*an unfiniſhed piece.* Buſt of an old Man with a long Beard, (No. 240)—*2d Imp.*; and Ditto—fine Copy

276 The fame, (No. 240)—FIRST IMPRESSION, *before* the Plate was reduced—extremely rare

277 Two. The Man with a Crucifix and Chain, (No. 241); and an old Man with large White Beard, (No. 242)—*very fine Impreffion*

278 Portrait of a Man with a fhort Beard, (No. 243)

279 The fame, (No. 243) *before the Hand was effaced*— EXTREMELY RARE

280 Abraham Vander Linden, (No. 244) FIRST IMPRESSION—*very fine*

281 Two. An old Man in a fur Cap, divided in the Middle, (No. 245); and Janus Silvius, (No. 246)

282 Two. A young Man mufing, (No. 248); and Manaffeh Ben Ifrael, (No. 249)

283 Doctor Fauftus, (No. 250)

284 Renier Hanslo, by Xavery

285 Renier Hanslo, No. 251)—*fine and rare*

286 Clement de Jonghe, (No. 252)—*4th Imp. fcarce*

287 The fame, (No. 252)—*3d Imp. very fcarce*

288 The fame, (No. 252)—SECOND IMPRESSION, EXTREMELY RARE, *before the Arch*

Fourth Day's Sale,

SATURDAY, MAY the 17th, 1800.

WORKS OF REMBRANDT's SCHOLARS.

JOHN LIVENS.

289 TWO. St. Jerome in a Cavern; and St. Francis, ditto

290 St. Jerome, ditto, *before the Plate was cut—very rare*

291 Two Heads—*very fine and rare*

292 Mercury and Argus, and 7 Heads, various

293 Seven Heads, various

294 Two. Ephraim Bonus, and Juſtus Vandelius—*very fine*

295 Four Heads, various

296 Six ditto, James Gouter, &c.

297 Six ditto

298 Four ditto

299 Anna Maria Schurman, by Suyderhoef—*very fine*

300 Four. Daniel Heinſius. Conſtantine Hugenius, by Voſterman. Nicolas Lanier, by Ditto; and Johannes de Heem, by P. Pontius—*all fine*

301 Three. Admiral Martin Tromp, by Dalen. Ditto by Francois; and Admiral Van Galen

JOHN GEORGE VAN VLIET.

302 Ten, a Set of Beggars—*very fine*

303 Twelve, a Set of single Figures—*fine and rare*

304 Eighteen, a Set of manual Trades, *ditto*

305 Five, the Senses, *ditto*

306 Six. An Officer, in Profile, with a Gorget and Chain, *1st and 2d Imp.* Raising of Lazarus— *fine Imp.* A Family Piece. The Rat-catcher; and St. Jerome.

307 Lot and his Daughters—BEAUTIFUL IMPRESSION —*extremely rare*

308 Six Portraits of Men—*the Set complete—scarce*

309 An old Woman reading—BEAUTIFUL IMPRESSION

310 Isaac blessing Jacob

311 Susannah and the Elders—*very fine*

312 Four. The Baptism of the Eunuch, after Rembrandt, Two, the same Subject, various; and St. Jerome in the Cavern

ETCHINGS BY REMBRANDT.

PORTRAITS CONTINUED.

313 Abraham France (No. 253) *6th Imp.*

314 Ditto (No. 253) *5th Imp.*

315 Ditto, (No. 253) *4th Imp.—very scarce*

316 Ditto, (No. 253) *3d Imp.* RARISS, *on India Paper,* from *Lord Bute's Collection*

D

317 Old Haaring, (No. 254) *with the Bur*—BEAUTIFUL IMPRESSION—*extremely rare*

318 Young Haaring, (No. 255)—*3d Imp.*

319 Ditto, (No. 255)—*2d Imp.*—*extremely fine and rare*

320 John Lutma, (No. 256)—*3d Imp.*

321 Ditto, (No. 256) *before the Window*—*very fine and rare*

322 John Affelyn or Crabbetjie, (No. 257)—*2d Imp.*

323 Ditto, (No. 257)—FIRST IMPRESSION, *with the Eafel, on India Paper*—*extremely fine and rare*

324 Ephraim Bonus, (No. 258)—*very fine and fcarce*

325 Wtenbogardus, (No. 259)—*ditto*

326 John Cornelius Sylvius, (No. 260)—*rare*

327 The Banker, or Gold Weigher, (No. 261)—FIRST FINISHED IMPRESSION—*extremely fine*

328 The little Copenol, (No. 263)—*5th Imp.*

329 Ditto, (No. 263)—*3d Imp.*—*very fcarce*

330 Ditto, (No. 263)—THE SECOND AND RAREST IMPRESSION, *generally efteemed the Firft, from the Earl of Bute's Collection*

331 Two. The great Coppenol, (No. 264)—*very fcarce.* The Head from the Plate when cut on India paper

332 The Burgo-mafter Six, (No. 265)—*a remarkable fine impreffion, extremely rare*

FANCY HEADS OF MEN.

333 Three Oriental Heads, (No. 266)—*fine 3d Impreffions, extremely rare*

334 Two. A young Man in a mezetin Cap, (No. 267) and Buft of an old Man, with a large Beard, (No. 268)

335 Five... Bust of an old Man, bald Headed, (No. 269). - Profile of a bald-headed Man, (No. 270). Same Subject smaller (No. 271) 1st Imp. —*very fine and rare*. Ditto, *2d Imp.*; and an old Man in an Oval, (No. 272)

336 Three. An old Man with a bald Head, (No. 273)—*very scarce*. Bust of an old Man with his Mouth open, (No. 274) *1st Imp.*—*very rare*; and Ditto, (No. 274) *2d Imp.*

337 Three. Bust of a Man with a high Fur Cap, (No. 276). Bust of a Man with a Beard from Ear to Ear, (No. 277) *1st Impression, extremely rare*; and Ditto, (No. 277) *2d Imp.*

338 Two... The Slave with a great Cap, (No. 278) *1st Imp. very rare*; Ditto, (No. 278) *2d ditto ditto.*

339 Two. Bust of a Man seen in Front in a Cap, (No. 280) *3d Imp. from the reduced Plate, very fine and rare*; and Ditto, (No. 280)—*scarce*

340 Ditto, (No. 280)—*2d Imp. before the Plate was cut*—PRESQUE UNIQUE—*very fine*

341 Ditto, (No. 280)—FIRST IMPRESSION, *before the Mark of Rembrandt*—*extremely fine*—UNIQUE

342 Two. Bust of a Man with Curling Hair, (No. 281) and Profile of a bald Old Man, (No. 282). —*very fine*

343 Two. Bust of a Man in a Fur Cap stooping, (No. 283), and Profile of a Bald Old Man, (No. 284)—*very rare*

344 Three. Bust of a Man singularly out-mouthed, No. 285). An Old Man with a large white Beard, (No. 284), and a Young Man, half length, (No. 287)

345 Two. A Man with a broad-rimmed Hat and Ruff, (No. 288), and Buſt of an Old Man with a large Beard and Fur Cap, (No. 289)—*very rare*

346 An Old Man in a rich Velvet Cap, (No. 290)— BEAUTIFUL IMPRESSION, *rare*

347 Three. Buſt of an Old Man with a very large Beard, (No. 292)—*1ſt Imp. very ſcarce*. Ditto, (No. 292)—*2d Imp.* and Portrait reſembling Rembrandt in a Mezetin Cap, (No. 293)

348 Two. A full Face Laughing, (No. 294)—*rare*, and the ſame Subject, *a reverſe—very fine, and undoubtedly the original Print*

349 Profile of a Man with a ſhort thick Beard, (No. 295)—EXTREMELY RARE AND FINE

350 A Philoſopher with an Hour Glaſs, (No. 296)— FIRST IMPRESSION, VERY FINE, OF EXTREME RARITY

351 Three. Buſt reſembling Rembrandt, No. 297) —*1ſt and 2d Imp.* and Head with a mutilated Cap, (No. 298)—*ſcarce*

352 Three. Man with Mouſtaches, in a high Cap, fitting, (No. 299)—1ſt Imp. *very ſcarce and fine.* Ditto, (No. 299)—*2d Imp.* and Ditto, (No. 299)—*a reverſe*

353 Buſt of a Man in a Cap—*one of Rembrandt's firſt Performances,* (No. 300)—3d Imp. *very ſcarce*

354 Ditto, (No. 300)—SECOND IMP. *extremely rare*—

335 Ditto (No. 300) FIRST IMP. *not mentioned by Ger-ſaint*—PRESQUE UNIQUE

356 Man's Head with Cap and Stay, (No. 301)— VERY FINE, AND A GREAT RARITY

357 Two. Buſt of a Bald-headed Man, (No. 302)— 1ſt Imp. *very ſcarce*, and Ditto, (No. 302)—2d *Imp. ſcarce and fine*

358 Two. An Old Man fleeping, (No. 303)—*very fine and fcarce*, and Ditto, the Copy

359 Four. An Old Man with a very large Beard, (No. 304). A Grotefque Head in a high Fur Cap, (No. 305)—*1ft Imp. very rare*. Ditto, (No. 305)—*2d Imp. fcarce*, and Ditto, (No. 305)—a Copy

360 Two. A Grotefque Head with the Mouth open, (No. 306) *very fcarce*; and Ditto, (No. 306)—*2d Imp*.

361 Portrait of an Officer, (No. 309) by Ferdinand Bol, *erroneoufly attributed to Rembrandt—fcarce*

PORTRAITS OF WOMEN.

362 The Great Jewifh Bride, (No. 311)—*very fine and rare*

363 Ditto, (No. 311)—FIRST IMPRESSION, PRESQUE UNIQUE

364 Three. Portrait of an Old Woman, refembling Rembrandt's Mother, (No. 313)—*2d. Impreffion—fcarce*. Ditto, (No. 318)—*3d Imp.—ditto*; and Ditto the fame Subject, *another Print*

365 Two. Little Jewifh Bride, (No. 312); and Portrait of an Old Woman, refembling Rembrandt's Mother, (No. 313)—FIRST IMPRESSION—RARE

366 Two. A Young Woman Reading, (No. 314)—*2d. Imp.—fcarce*; and Ditto, (No. 314) *3d Imp.—ditto*

367 Ditto, (No. 314)—FIRST IMPRESSION—EXTREMELY RARE.

368 Two. Rembrandt's Wife, (No. 316); and an Old
Woman, refembling his Mother (No. 317)—
fcarce

369 Two. Rembrandt's Mother, (No. 318)—FIRST
IMPRESSION—*very fcarce;* and Ditto, (No. 318)
—*2d Imp.—ditto*

370 Two. Head of an Old Woman, etched no lower
than the Chin, (No. 319)—*very fcarce;* and
Ditto, with a Hood, (No. 320)—*very fcarce
and fine*

371 Two. Buft of an Old Woman, lightly etched,
(No. 321); and Ditto in a Black Veil, (No. 322)
—*finifhed impreffions—very fcarce*

372 Ditto, (No. 322)—FIRST IMPRESSION—*extremely
rare and fine*

373 Four. A Woman with a Bafket, (No. 323). A
Morifco, (No. 324). Buft of a Woman, lower
part, oval, (No. 325); and a Woman in a
large Hood, (No. 326)

STUDIES AND SKETCHES.

374 Two. Head of Rembrandt, and other Studies,
(No. 329). Rembrandt's Wife; and 5 other
Heads, (No. 331)

375 Two. Three Heads of Women, (No. 333); and
Three Ditto, one Afleep, (No. 334)

376 Two. Women in feparate Beds, and other fketches,
(No. 335)—VERY FINE AND RARE

377 Two. Rembrandt's Head and others, (No. 337);
Sketch of a Tree, &c. (No. 339)

PORTFOLIOS WITH LEAVES.

378 A large Portfolio, *fuperbly bound in Morrocco,* en-
 titled Rembrand's Works, vol. 1

379 Another, *ditto,* Ditto, vol. 2

380 Another, *ditto,* Ditto, quarto, vol. 3

382 Another large ditto, Ruffia Back, vol. 5

CPSIA information can be obtained
at www.ICGtesting.com
Printed in the USA
BVHW041426241218
536331BV00015B/655/P